The Stations of the Cross

VINCENT SHERLOCK

First published in 2017 by Messenger Publications

ISBN 978 1 910248 57 7

Designed by Messenger Publications Design Department
Typeset in Baskerville and ChopinScript
Printed by Johnswood Press Ltd

MESSENGER
PUBLICATIONS
JESUITS in IRELAND

Messenger Publications,
37 Lower Leeson Street, Dublin 2
www.messenger.ie

The name of God is Mercy

– Pope Francis

The Camino of the Cross: Calvary Way

Walk the way of the cross with the woman found committing adultery

A well-accepted method of praying on the mysteries of the life of Christ has been with the imagination. This was popularised in the *Spiritual Exercises of St Ignatius Loyola*. Staying close to the scripture meaning, we imaginatively pray on the life of Jesus and maybe other mysteries encased within it. In making the Stations of the Cross we might put ourselves into the mind of those who watched or followed Jesus on his way. In this book, we follow with the woman who was found in adultery, imagining her watching Jesus on the way to Calvary.

This is a way of entering into the mystery of the event; while it may not be historical (though she could have been there, living in Jerusalem), it is faithful to the meaning of the event, and to the people we call on in imagination. It also engages us powerfully in the mystery of Christ's life that we contemplate.

Gospel Passage (John 8:1-11)

Jesus went to the Mount of Olives. At daybreak he appeared in the temple again; and as all the people came to him, he sat down and began to teach them.

The scribes and Pharisees brought a woman along who had been caught committing adultery; and making her stand there in full view of everybody, they said to Jesus, 'Master, this woman

was caught in the very act of committing adultery, and Moses has ordered us in the Law to condemn women like this to death by stoning. What have you to say?' They asked him this as a test, looking for something to use against him. But Jesus bent down and started writing on the ground with his finger. As they persisted with their question, he looked up and said, 'If there is one of you who has not sinned, let him be the first to throw a stone at her.' Then he bent down and wrote on the ground again. When they heard this they went away one by one, beginning with the eldest, until Jesus was left alone with the woman, who remained standing there. He looked up and said, 'Woman, where are they? Has no one condemned you?' 'No one, sir' she replied. 'Neither do I condemn you,' said Jesus 'go away, and do not sin any more.'

The Response

I never forgot that moment. They may not have had the stones in their hands but they knew where to get them. They said I should be stoned – he didn't seem to disagree but said 'let anyone that hasn't sinned throw the first stone'. I braced myself because I knew they were a 'holier than thou' lot, and felt sure the pelting would begin. The next moments were amazing. Silence, then a bit of shuffling and I think I heard a few stones falling on the ground. I dared not look but, in time, had a sense of being on my own – well not fully, he was still there, doodling on the ground. 'Where are they?' He asked. 'Have they all left? No stones, no condemnation?' 'They're all gone', I said, daring not raise my voice above a whisper … that way, I thought he'd not hear the tears in my voice. 'I don't condemn you either, go away now and sin no more.' I never was too far away from him after that. I'm not sure he knows – but I saw the genuine article that day. He was different from anyone I'd ever met before or since. So I was there on those last days near Calvary.

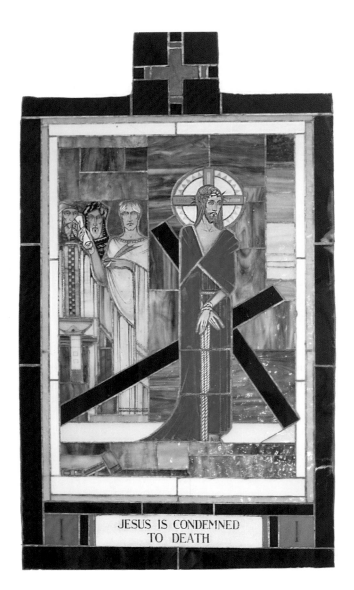

JESUS IS CONDEMNED
TO DEATH

6

He's Condemned

We adore you O Christ, and we praise you
Because by your Holy Cross you have redeemed the world

They didn't stone me in the end, but some of the same faces that wanted to are in the crowd, some of the same voices shouting lines from the Law. 'You're no friend of Caesar's if you let this man go. He claims to be the son of God.' I watched Pilate. He looked so uncomfortable on that throne of judgement. I thought he'd be better on his hunkers on the ground. Somehow he hadn't the heart, maybe the courage, of Jesus and instead of saying 'let the one here who has never got it wrong, condemn him', he said 'Let him be crucified.' My heart sank. I thought I could hear those gathering stones. To this day, I hate to think of anyone being wrongly condemned.

The name of God is Mercy

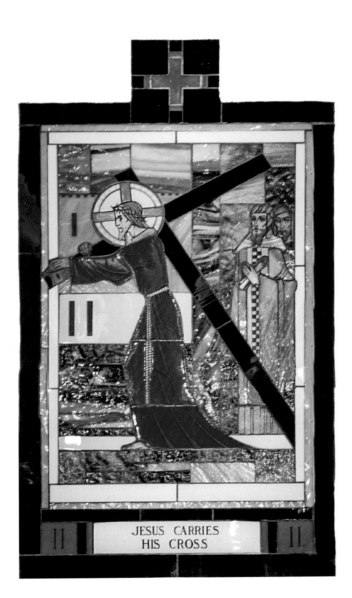

JESUS CARRIES
HIS CROSS

He's Made Carry His Cross

We adore you O Christ, and we praise you
Because by your Holy Cross you have redeemed the world.

Strange it's called 'his cross', as if he claimed any ownership of it or deserved it. The cross was neither of his making or choosing, but he was under it, carrying its weight. I thought again of that day and wished I could do something to help – say something, but again I was speechless. Someone said that, 'the best way for evil to triumph in the world is for good people to say nothing.' Since that day, though I still got it wrong on many occasions, I considered myself a good person. I said nothing. I should have cried 'leave him alone!' – maybe we all should have.

The name of God is Mercy

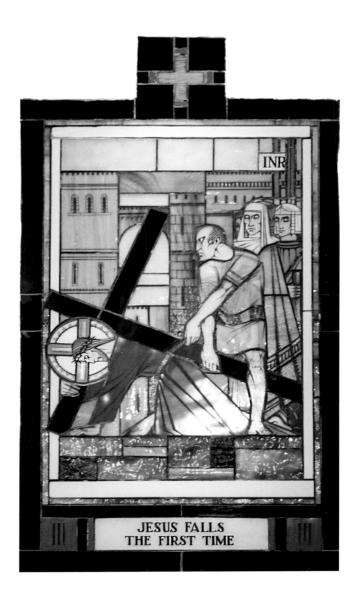

JESUS FALLS
THE FIRST TIME

III

A First Fall

We adore you O Christ, and we praise you
Because by your Holy Cross you have redeemed the world.

It was awful. I knew he was struggling. Why wouldn't he be? They'd beaten him to a pulp, rammed thorns into his head, robbed him of his dignity and then he was on the ground. No doodling this time. He just seemed to lay there. It seemed like forever but, not for the first time, he found the strength from somewhere – 'you're your Father's son', I thought. I looked into the crowd and, though some were like me, shocked and saddened, others were gloating. I thought: how quickly people forget. The man who fed a multitude, cured the sick, comforted the afflicted, and some just didn't seem to care that he was allowed fall. That's the way I see it – not that he fell but he was allowed fall. It shouldn't have happened.

The name of God is Mercy

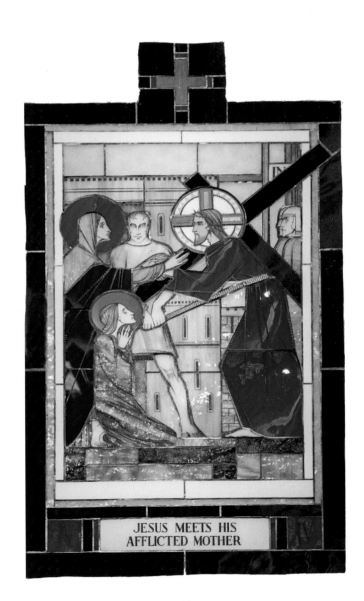

JESUS MEETS HIS
AFFLICTED MOTHER

IV

A Mother Met

We adore you O Christ, and we praise you
Because by your Holy Cross you have redeemed the world.

I'd seen her of course on other days. She never forced her presence but it was constant. They all said she was a good woman; 'Something different about her'. Never more so than now and yet, in some ways, I never felt more like her. The tears in her eyes, I'd felt those many times; and the darkness of her expression, I'd known that too. Though I felt sorry for her, I felt a connection. She struck me as someone who knows what it means to suffer the confusion often found in family relationships. Yet, the real wonder of the mother is found here: she is with her son when he most needs her. Words, as far as I know, were not spoken. It was in the eyes, the contact, and the reassurance that he was not alone.

The name of God is Mercy

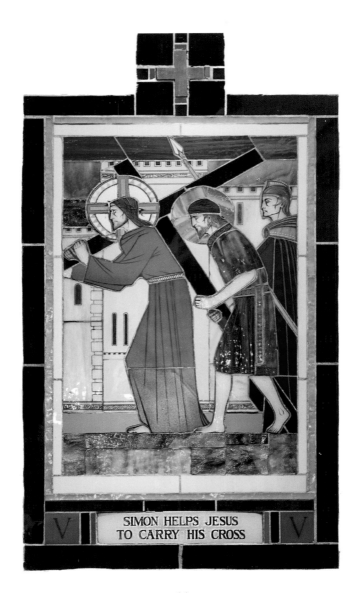

SIMON HELPS JESUS
TO CARRY HIS CROSS

V

A Helping Hand

We adore you O Christ, and we praise you
Because by your Holy Cross you have redeemed the world.

I met Simon afterwards, I'd known him for a while. He never struck me as the courageous type. He'd like to be in the know and generally stood where he'd have a good view. That was his downfall that day, as the soldiers hadn't far to stretch to drag him to the cross. He told me he was petrified. There was no gentleness in the soldiers, and he didn't know what they wanted. 'Pick up the cross', they shouted at him. 'Why, what have I done?' he replied. He told me they said nothing, just placed the cross on his shoulders. At first it didn't feel that heavy, but then he realised that Jesus was carrying the bulk of the weight. He told me that he tried to take more of it as they went on but that, no matter how much of the cross he carried, the weight didn't increase. 'I wonder', he asked 'is that because Jesus was carrying the weight for me?' Strange, they say Simon helped Jesus but, as Simon recalls it, Jesus helped him. Either way, they travelled together. I asked whether Jesus had said anything to him. Simon told me 'no, but to be honest, he didn't need to. We both knew what was happening'.

The name of God is Mercy

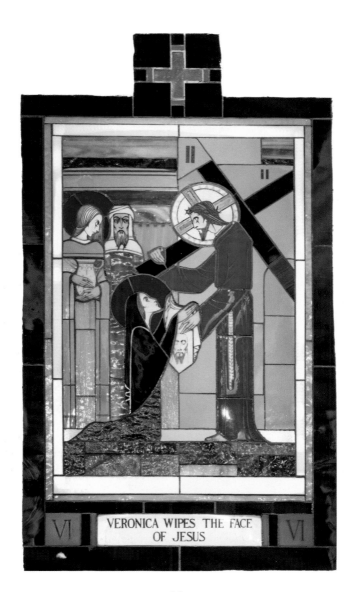

VERONICA WIPES THE FACE
OF JESUS

VI

A Loving Hand

We adore you O Christ, and we praise you
Because by your Holy Cross you have redeemed the world.

This is my favourite one. I knew they didn't know me, I felt certain they wouldn't remember me. Just another woman along the way. When it suited them, they totally ignored women – the soldiers, the authorities – but women were always there. There was a towel. Where did it come from? I couldn't tell you. It just seemed to be there. It was clean and he wasn't. It was soft and nothing else around him was soft. It just seemed the right thing to do. A soft, clean and dry towel on a broken, sweaty and hurting face – of course it was the right thing to do. I stepped forward and did the right thing. It was payback time. It's not even my name, Veronica, but someone put that name on me afterwards. They say it's something to do with being the 'true image' of him. I'm happy to be called Veronica. 'Neither do I condemn you', I said, as I put the towel to his face. 'I know you don't', he replied. Do you know, I think he smiled too! Kindness does that, it brings out the smile, even in the most difficult situations.

The name of God is Mercy

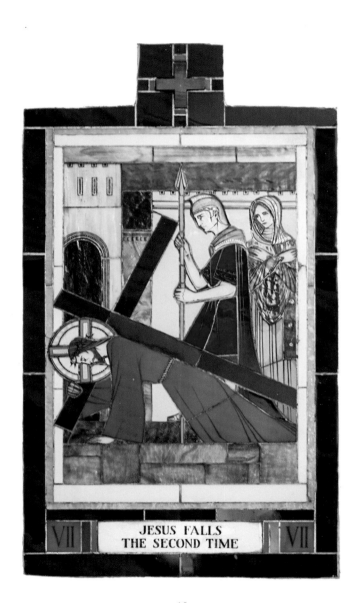

VII JESUS FALLS
THE SECOND TIME VII

VII

Falling Again

We adore you O Christ, and we praise you
Because by your Holy Cross you have redeemed the world.

I was still clutching the towel. Of course I'd have left it with him but he had no hands free. I hadn't seen the image of his face at that stage. I still remembered him doodling on the ground. I wondered what he had written there – nobody ever said. The ground was going through my mind and, as I looked up, I could see he was down – on the ground. They were roaring at him to get up. The day was dragging on and they had things to do, places to go and people to see. So did he! I thought again of the doodling, the scribbles on the market square and wondered what he'd written. There was no mistaking his writing now. He's writing in the ground, even as he falls to it, 'I'm here for you, this is happening for you, my Father only wants what's best for you, even as I fall again.'

The name of God is Mercy

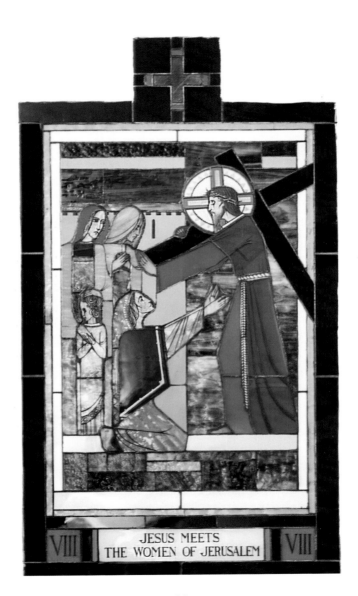

VIII · JESUS MEETS THE WOMEN OF JERUSALEM · VIII

VIII

The Women of Jerusalem

We adore you O Christ, and we praise you
Because by your Holy Cross you have redeemed the world.

I wasn't part of that group. The women of Jerusalem, unlike him, never fully forgave me for my 'slip'. Some of them nodded at me in a way bordering on kindness but most kept their distance. They were crying their eyes out. Like at the Fourth Station, I felt a connection with them. Yet I wasn't part of the group. He told them, in a roundabout sort of way, that their tears were noticed and that they shouldn't cry just for him but rather for anyone who failed to grasp what his message had been. Even that message about the throwing of the first stone. He'd hardly moved when one of them walked over to me, put her hand in mine and said, 'You did the right thing there with the towel.' She seemed to stop crying, as if she'd understood something for the first time.

The name of God is Mercy

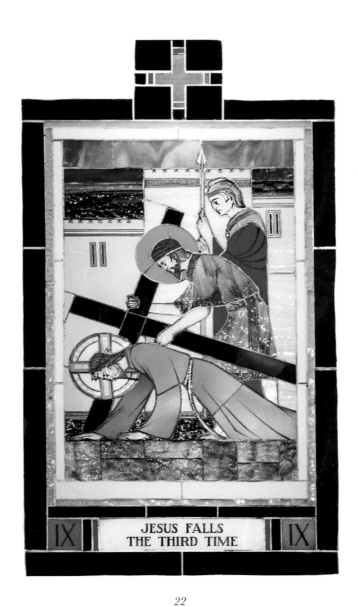

JESUS FALLS
THE THIRD TIME

IX

A Third Fall for Jesus

We adore you O Christ, and we praise you
Because by your Holy Cross you have redeemed the world.

Simon said this one was down to him. He lost his footing and as he fell he pushed Jesus to the ground. He said he felt badly about this but wondered if maybe it was a reminder that when a man falls he brings others with him. It was to be the final fall on the way, but led to the refinding of feet, and to facing the road that was necessary on that Friday. Jesus, Simon recalls, 'Looked back at me and sort of nodded. It's as if he was saying, "I'm with you always Simon – I know you didn't mean to fall or bring me down. We can, we will, we must get up again."'

The name of God is Mercy

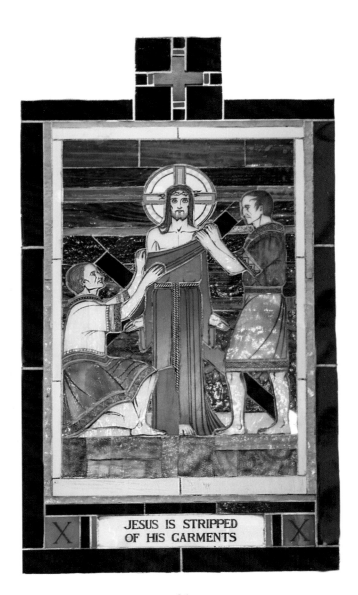

JESUS IS STRIPPED
OF HIS GARMENTS

Garments and Dignity

We adore you O Christ, and we praise you
Because by your Holy Cross you have redeemed the world.

I just didn't seem able to get away from the first time I met him. I wasn't left with much clothing the day they dragged me down that street. Just enough; but I knew it was less than I needed for dignity's sake. I really resented them taking his clothes. No, I didn't say it but I truly felt it was wrong. The woman who had walked over to me after he had spoken to her group, said 'there's no need for that' and there wasn't. As if they'd not taken enough, they actually cast lots to see who'd bring home his garments. I know for a fact, the man that won didn't bring them home. They were just thrown there, like everything else, they got lost in the bitterness of an angry mob. I've never been that comfortable in a crowd, especially when there's no shape to it, no heart in it. That was certainly one of his gifts, he put 'fresh heart' into people and, when they stifled that in the tearing of his clothes, something sacred was lost.

The name of God is Mercy

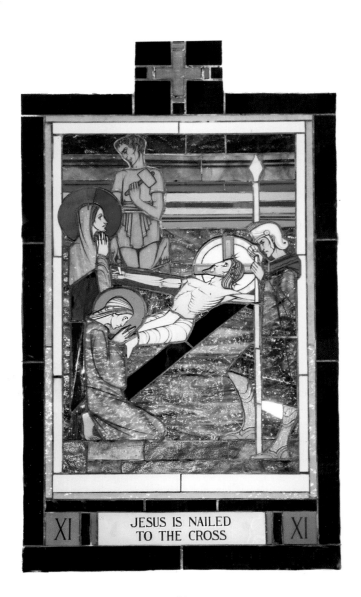

XI JESUS IS NAILED
TO THE CROSS XI

XI

He's Nailed to the Cross

We adore you O Christ, and we praise you
Because by your Holy Cross you have redeemed the world.

I thought I had heard stones dropping that first time we met, but I'll never get the sound of the hammers out of my head. He didn't scream. It was as if he'd crossed a threshold of pain, but there was something deafening in hammer on nail – he was bound to the cross. I thought how he'd bound himself to me, to so many, during the years. No nails, no pressure, just that ability to be at one with us. Someone said that when John asked him where he lived he said 'come and see'. I saw his mother again and John. Jesus said something to John about looking after the mother. 'Where do you live?' he might have asked him. I'm told that John brought Mary there, made room for her there. Even in cruelty, we need to connect with people, do the right thing by people, otherwise the hammer and nail do more than bind his hands to wood, they stall us on the road to God.

The name of God is Mercy

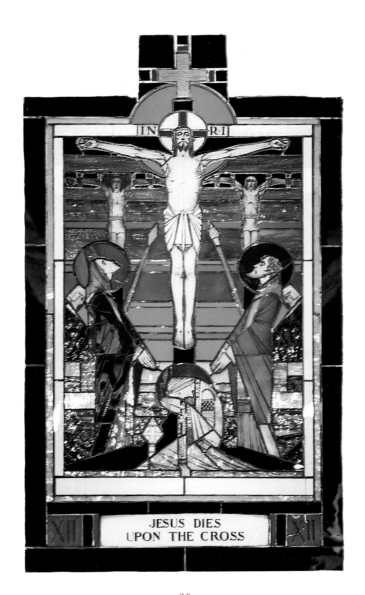

JESUS DIES
UPON THE CROSS

XII

It is Accomplished

We adore you O Christ, and we praise you
Because by your Holy Cross you have redeemed the world.

They talk about the veil of the temple tearing in two. I'm not sure what that means but I know my heart broke in two just at that moment, when he cried out 'it is accomplished'. They say he had spoken with the other two men who were crucified on each side of him. I didn't hear anything said. People who were closer to it than I, said he had he'd told one of them that paradise would be there waiting for him. Was that part of the accomplishment too? That, even to the end he could win people, encourage people to be the best version of themselves? If so, then he must have died happy, because I know for sure that one of the soldiers had a change of heart too. Oddly enough, I'm fairly sure he's the one that won the raffle for the clothes. Maybe he left them there after all, out of respect. It's absolutely never too late to recognise him, broken in bread, broken in body.

The name of God is Mercy

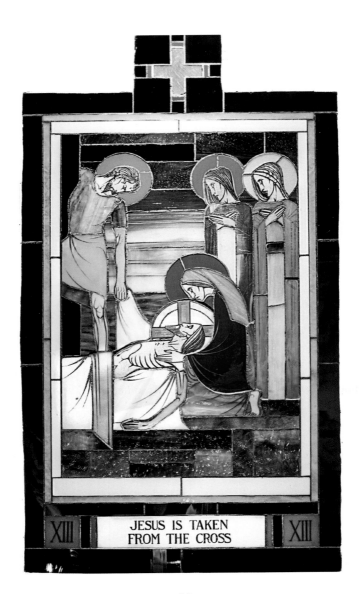

XIII JESUS IS TAKEN
FROM THE CROSS XIII

XIII

He is Taken Down from the Cross

We adore you O Christ, and we praise you
Because by your Holy Cross you have redeemed the world.

Mary may well have been silent when she met him at the Fourth Station, but her silence was well and truly broken here. It's not that she said much or gave out to people, but she cried so much that her tears almost found a voice of their own. My heart went out to her. Thankfully people who knew her better than I, people like John, drew close and found some way, maybe a few words or maybe just silence, to console her. I heard her say, 'They have no wine'. I'd heard years earlier that she said the same thing to Him at a wedding feast. That day, as I now understand it, he worked his first miracle. Was she daring to hope for another? I think she could just as easily have said 'I have no wine'. She needed a miracle. We all did.

The name of God is Mercy

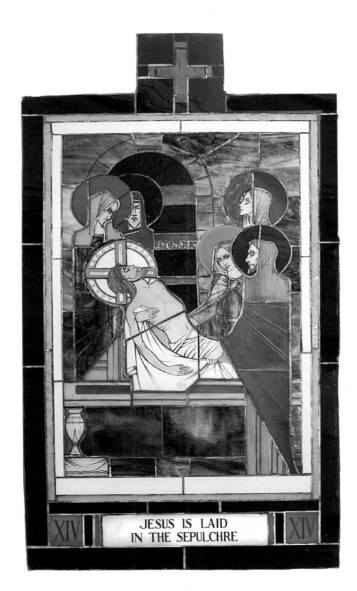

XIV | JESUS IS LAID IN THE SEPULCHRE | XIV

XIV

Joseph's Tomb Receives the Body of Jesus

We adore you O Christ, and we praise you
Because by your Holy Cross you have redeemed the world.

I didn't know his foster father, Joseph, or Joseph of Arimathea. I thought it strange that once again a man named Joseph was offering him shelter, and that just as his life began in a borrowed stable, so it seemed to end in a borrowed grave. I was glad both Josephs did the decent thing by him and by his mother. After the cruelty of the Calvary Way, it seemed 'right and just' that he be given a decent burial. It was rushed – those people so well versed in the Law, including some of my original accusers, insisted he be buried before the Sabbath. For once I was glad of their rules if it meant he wasn't left in the open gaze of people for long. They placed him in the tomb. I watched with a few women of Jerusalem; we linked arms and I'm certain I heard him say 'go away now and sin no more'.

I'm glad we met. I'm glad I was there, when they crucified my Lord. God knows, he knows, I owed him that much. Of course, had it not been for my 'sin', chances are I'd not have come to know him as well as I did.

The name of God is Mercy